REBEL COLOURING

FOR

GIRLS

MOTIVATING MESSAGES AND MARVELLOUS MANTRAS TO COLOUR AND CREATE

Rebel Colouring For Girls

Motivating Messages & Marvellous Mantras To Colour & Create

by Christina Rose

First published in the United Kingdom in 2017 by
Bell & Mackenzie Publishing Limited

ISBN: 978-1-912155-55-2

Created by Christina Rose
Contributors: Letitia Clouden

BELL & MACKENZIE
PUBLISHING LIMITED

www.bellmackenzie.com

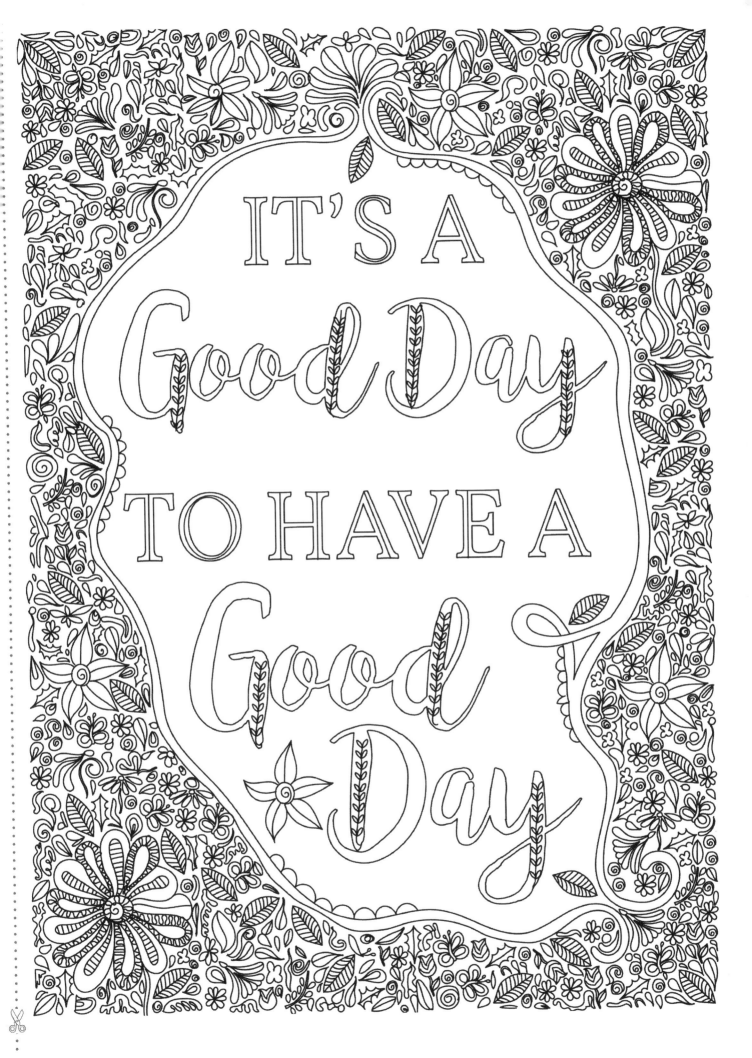

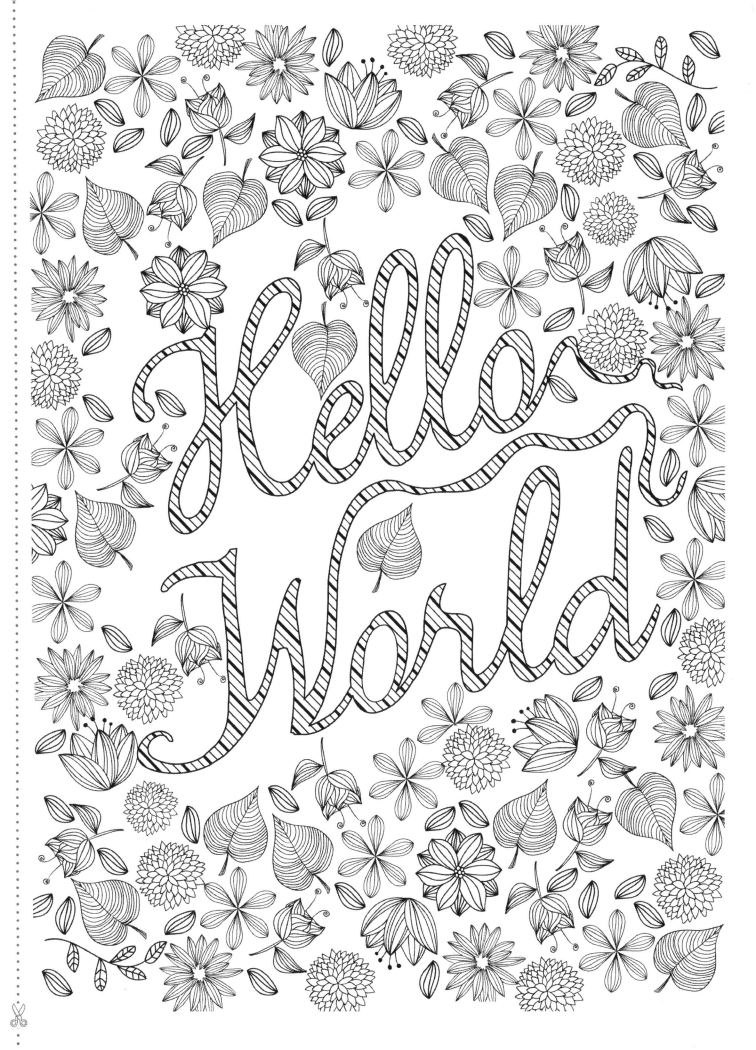

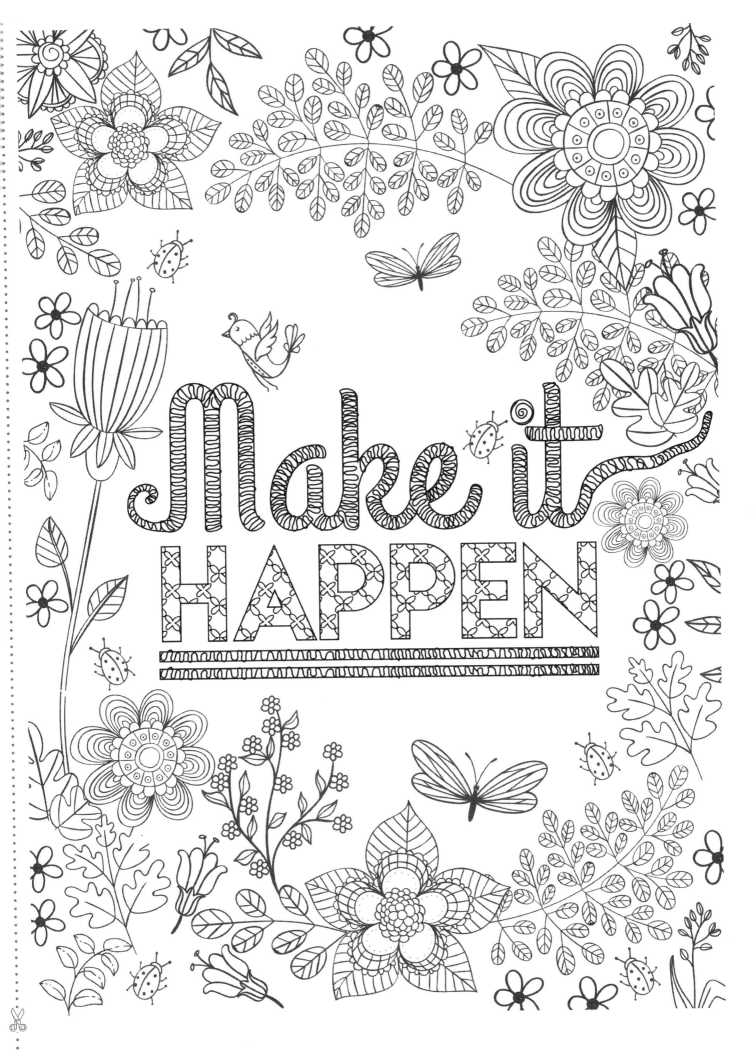

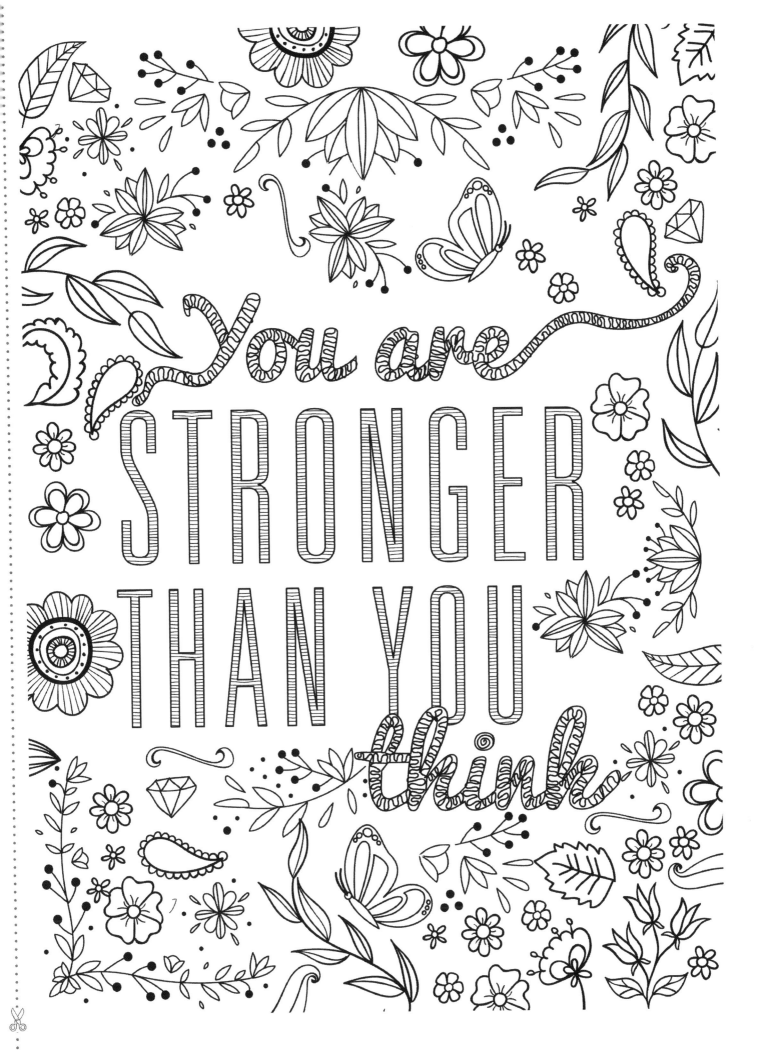

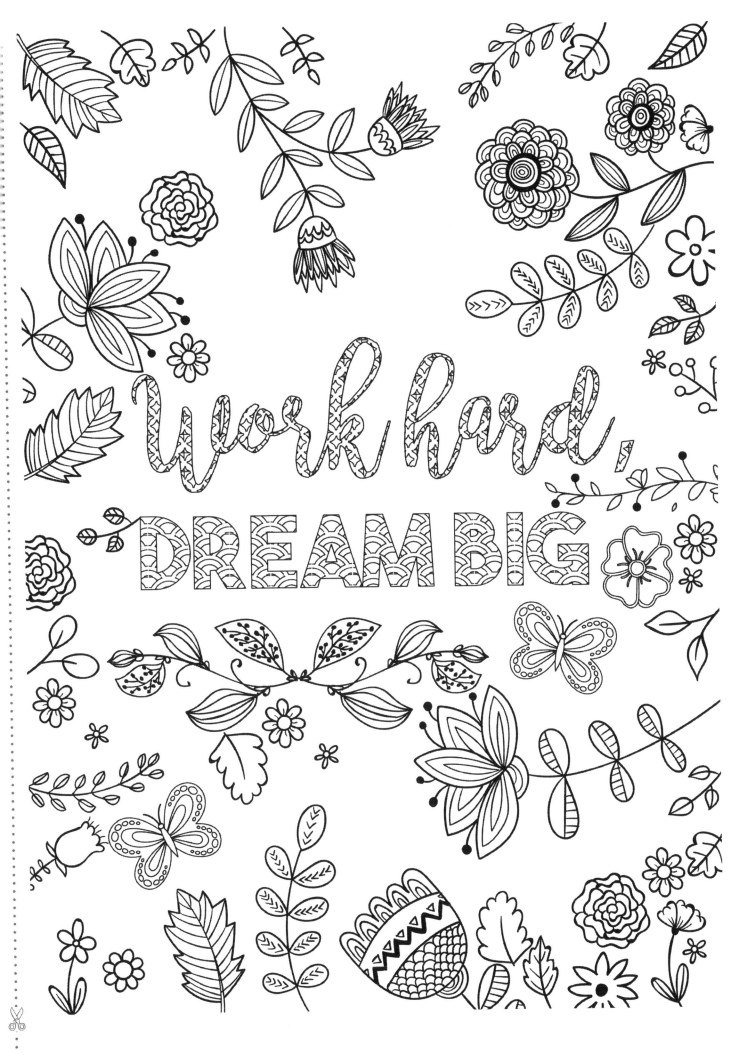

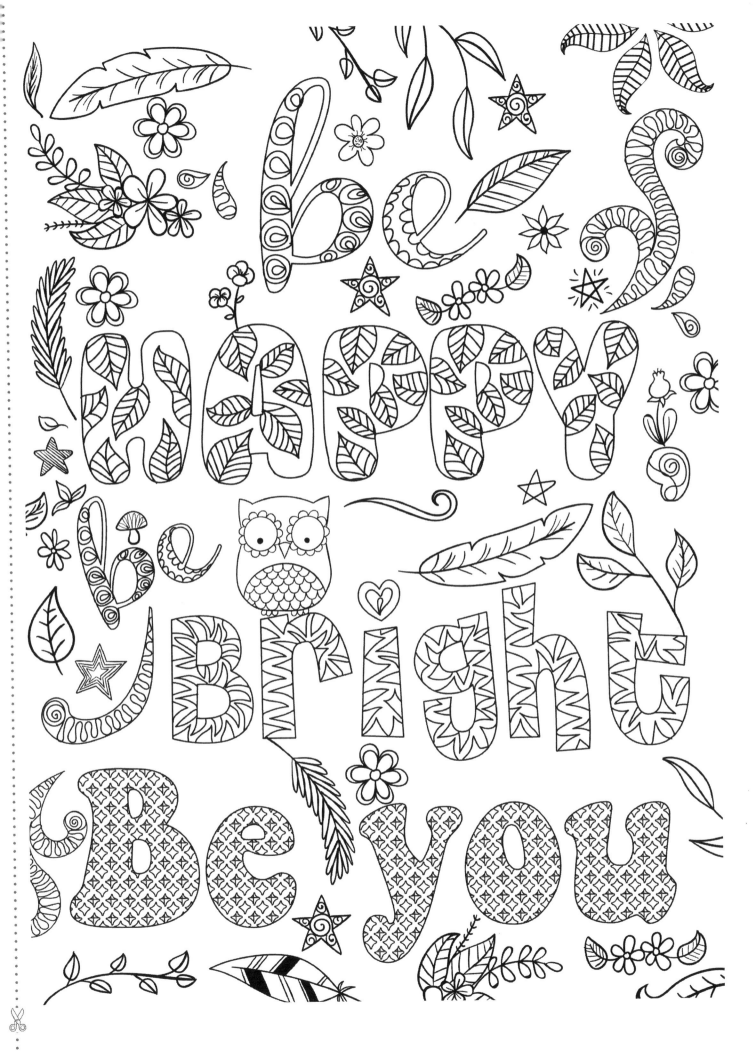

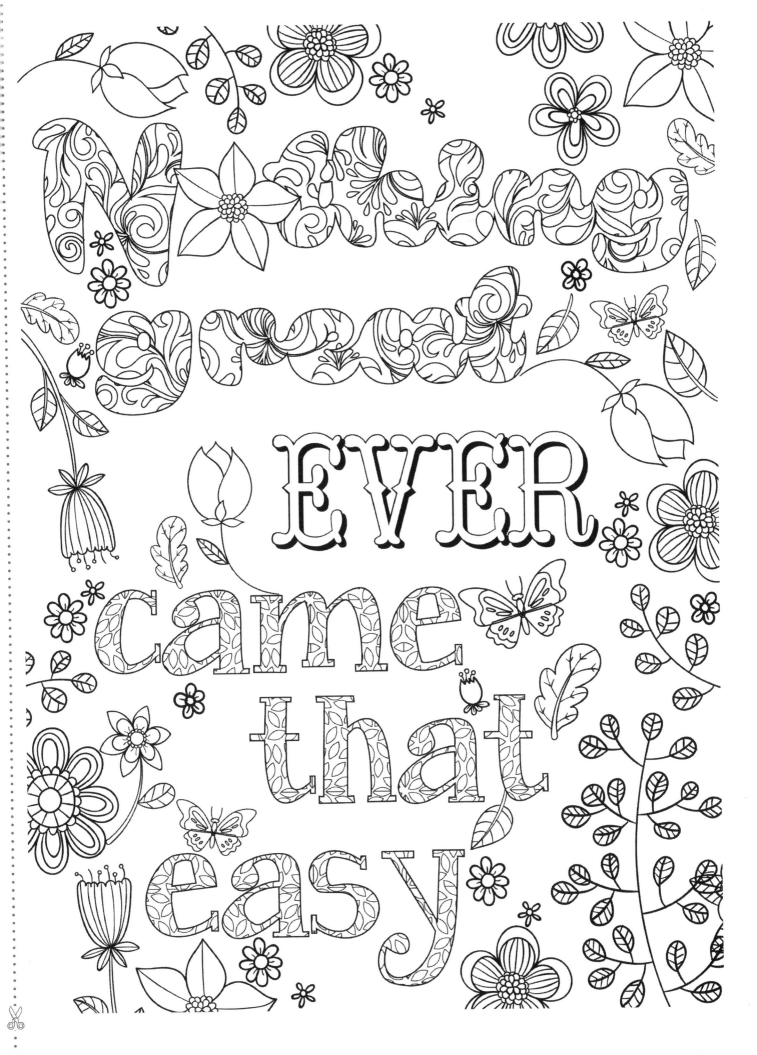

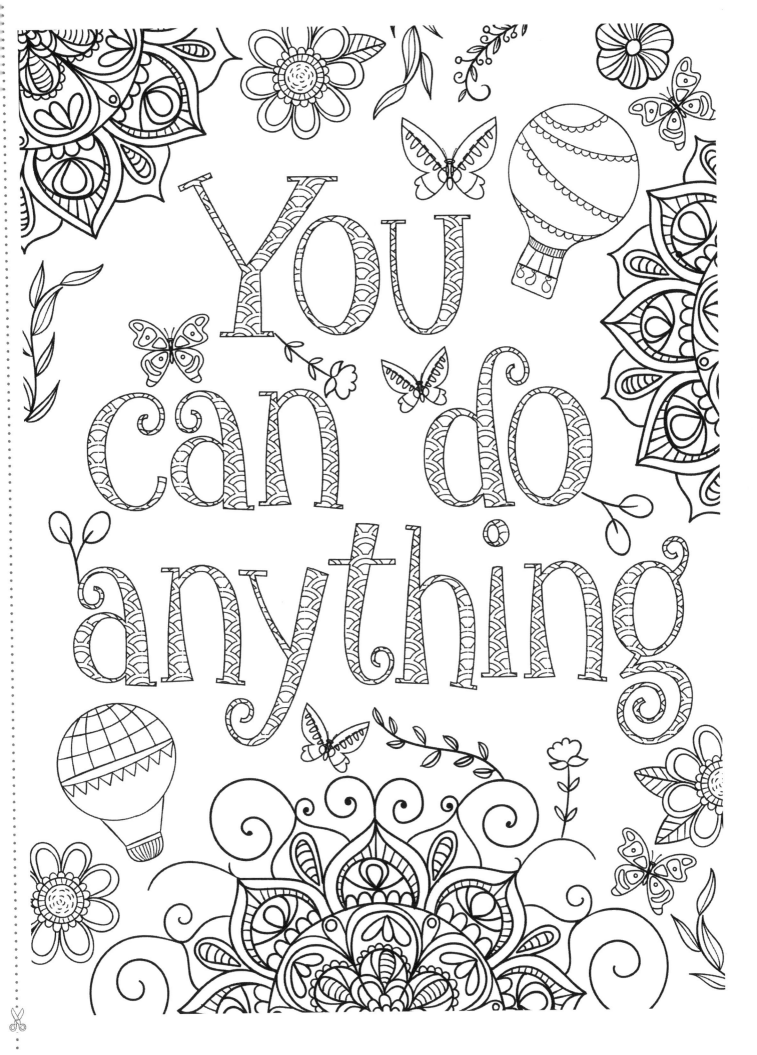

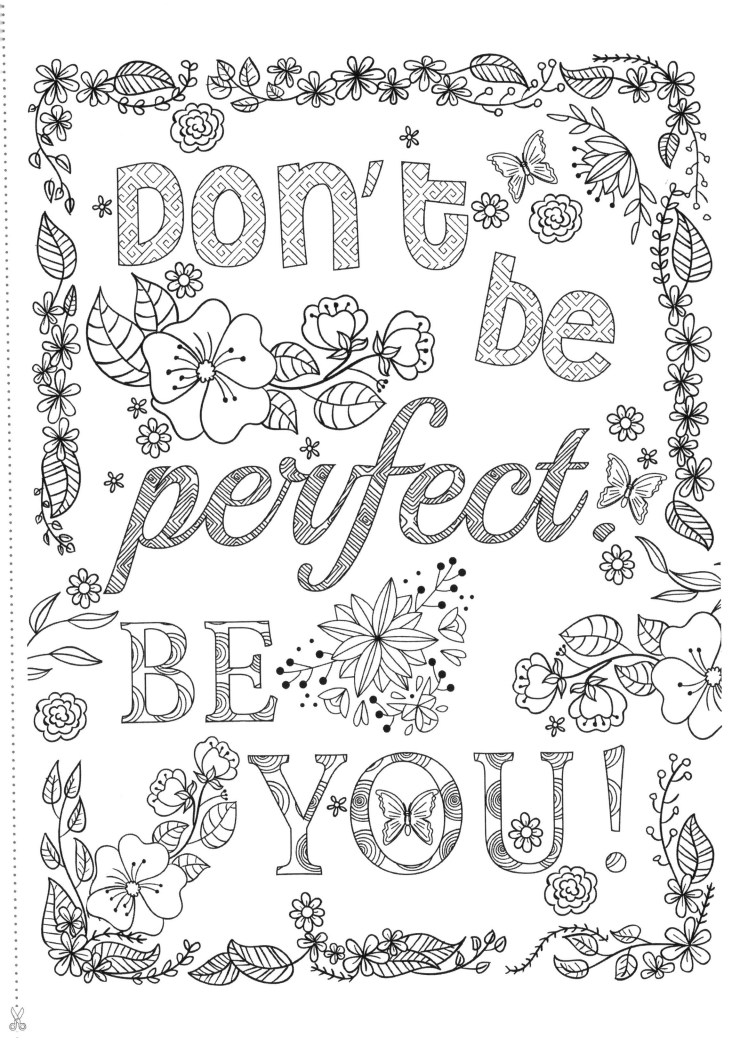

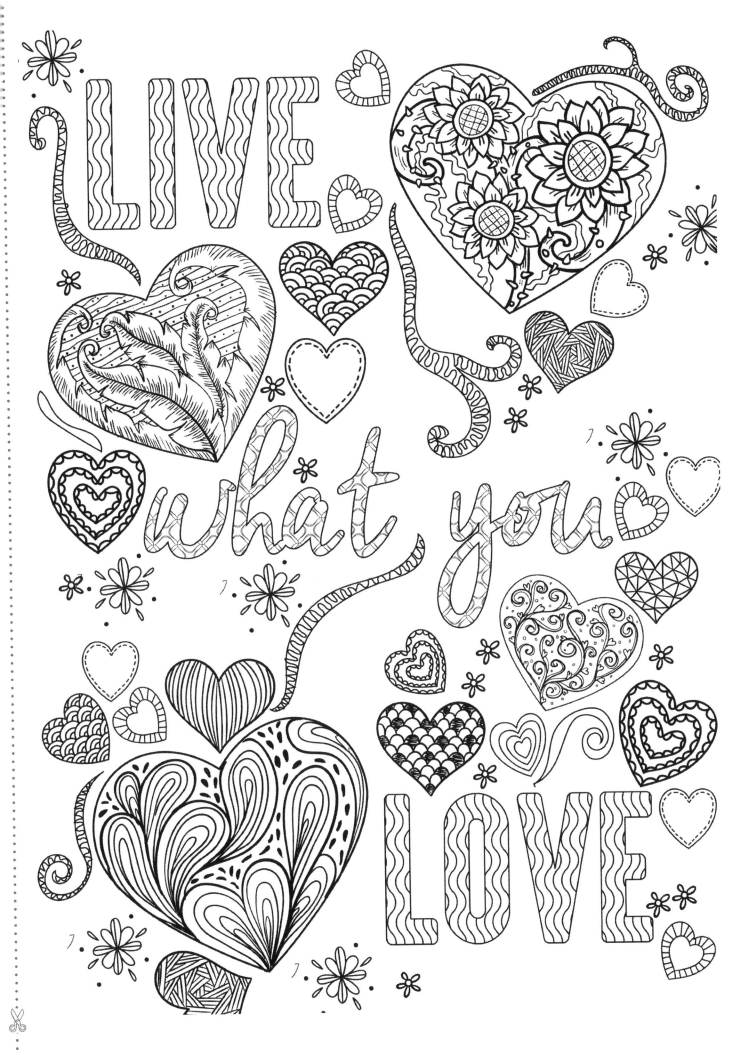

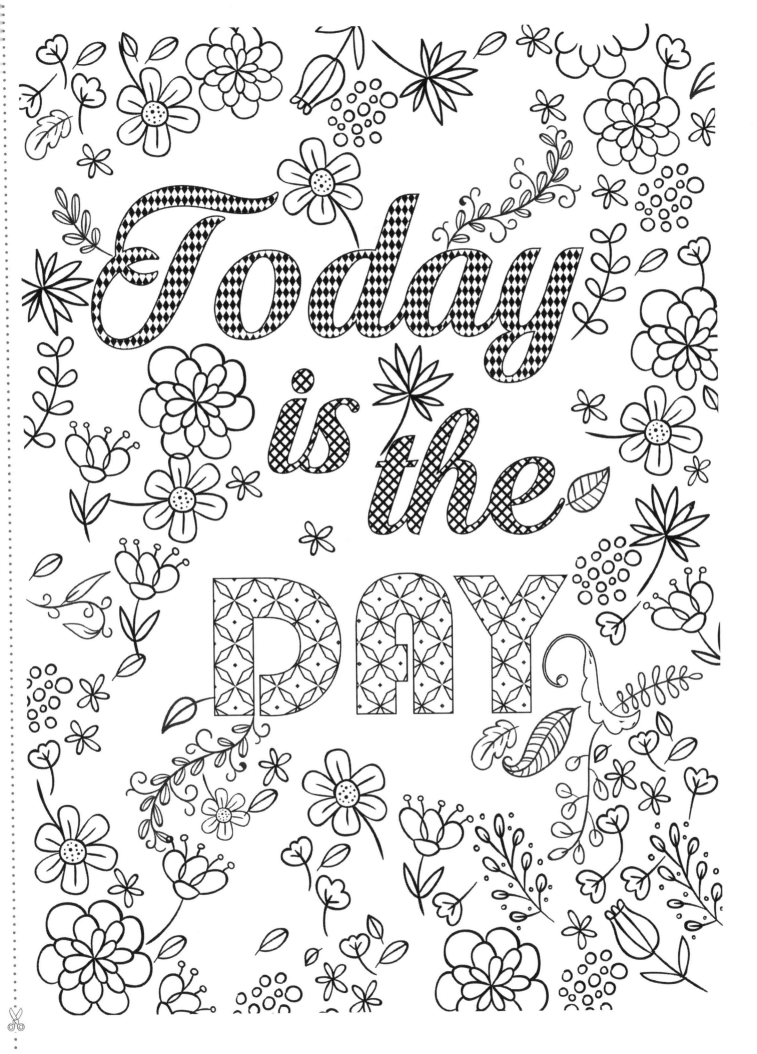

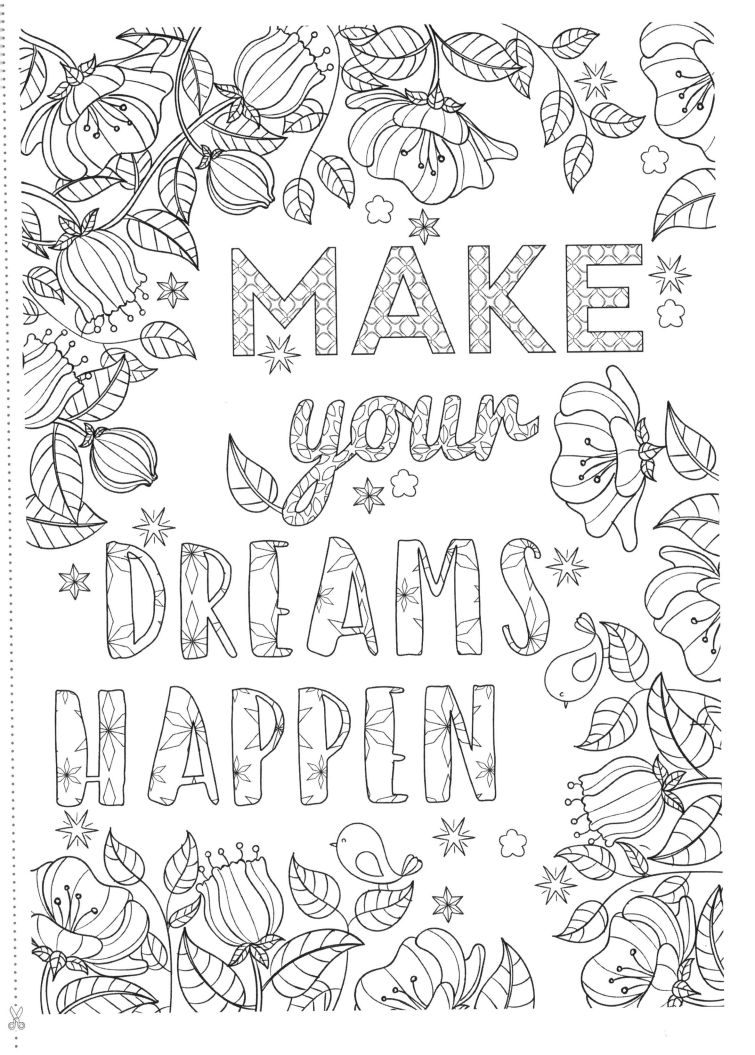

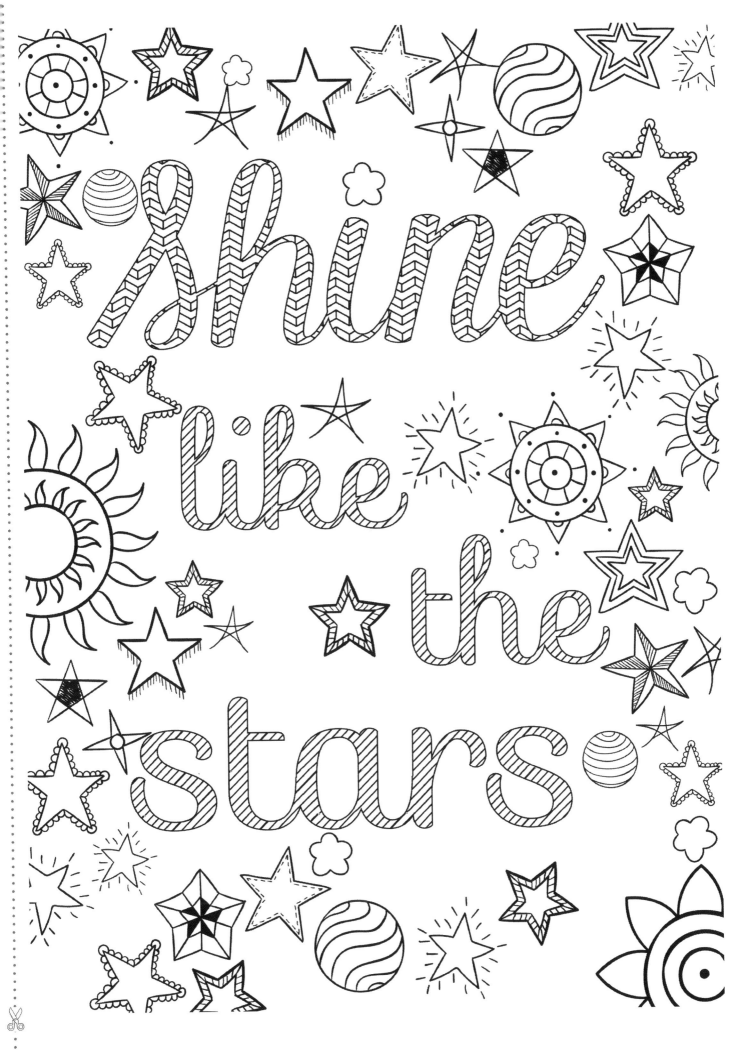

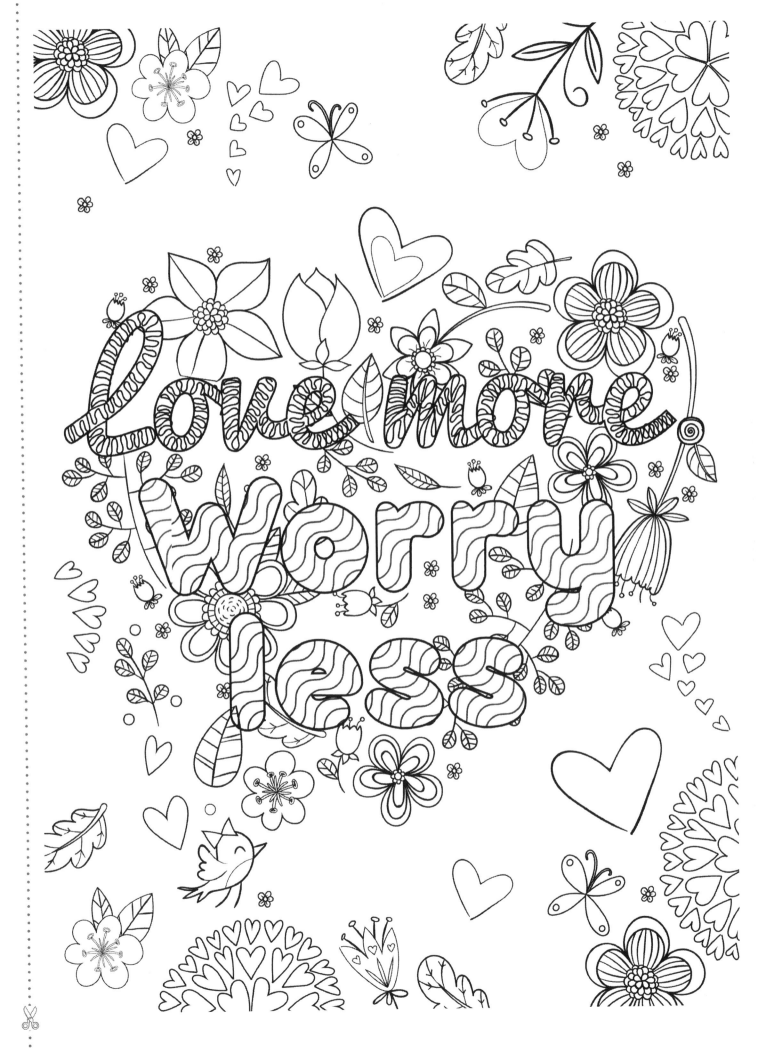

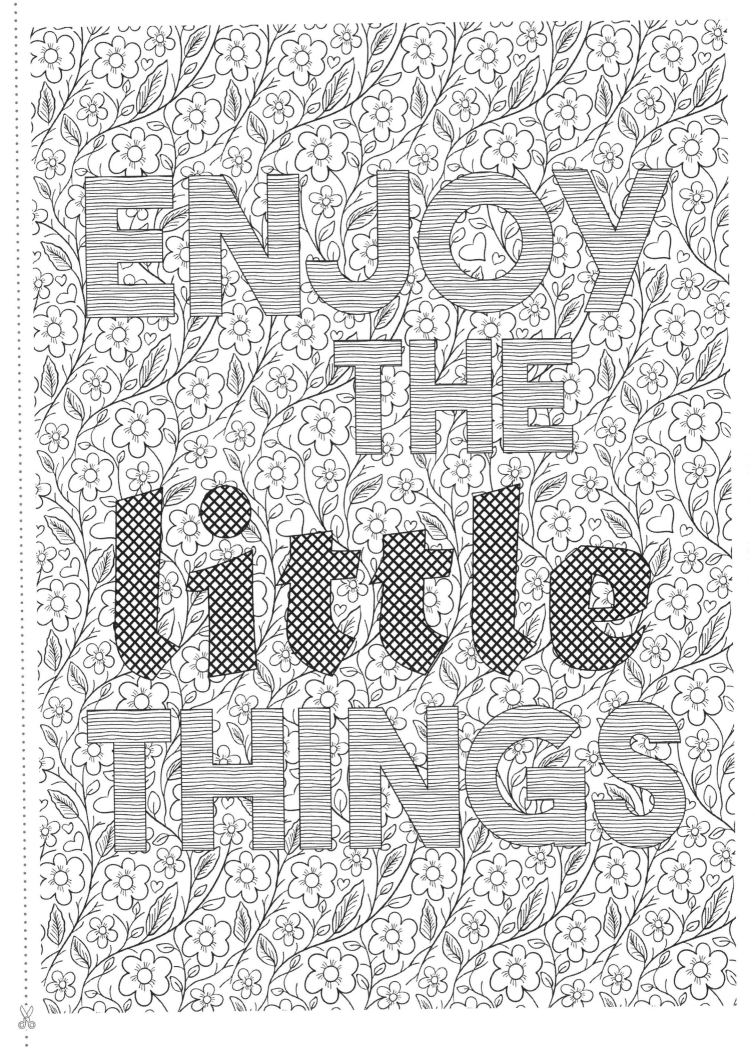

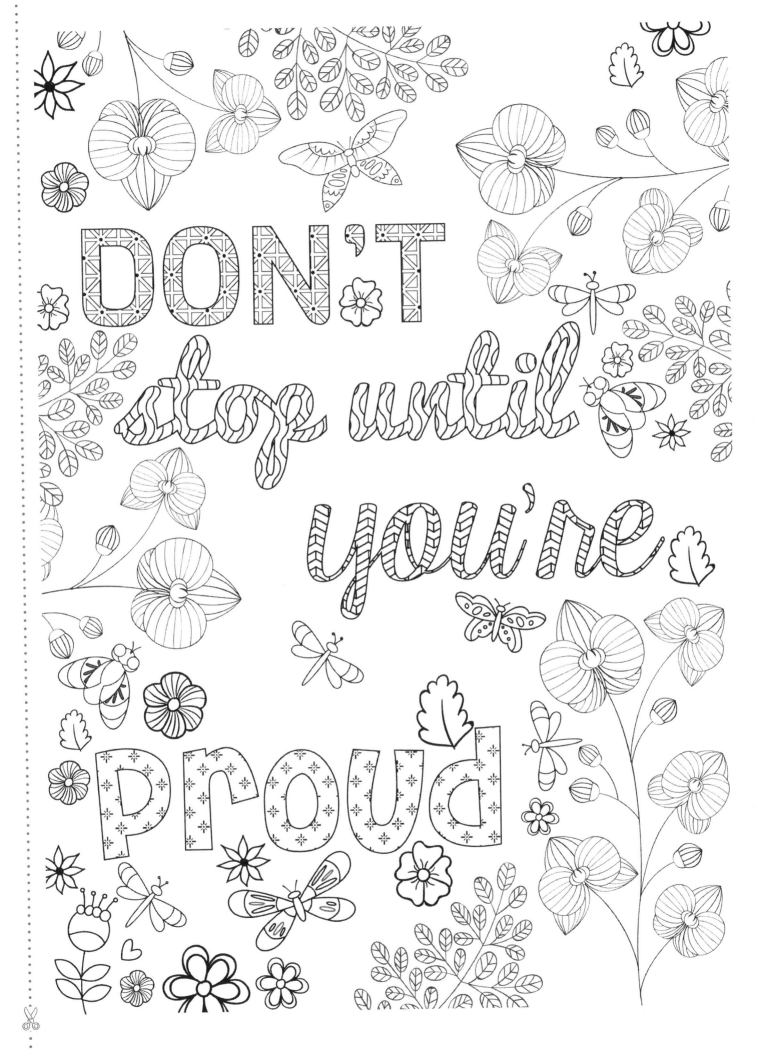

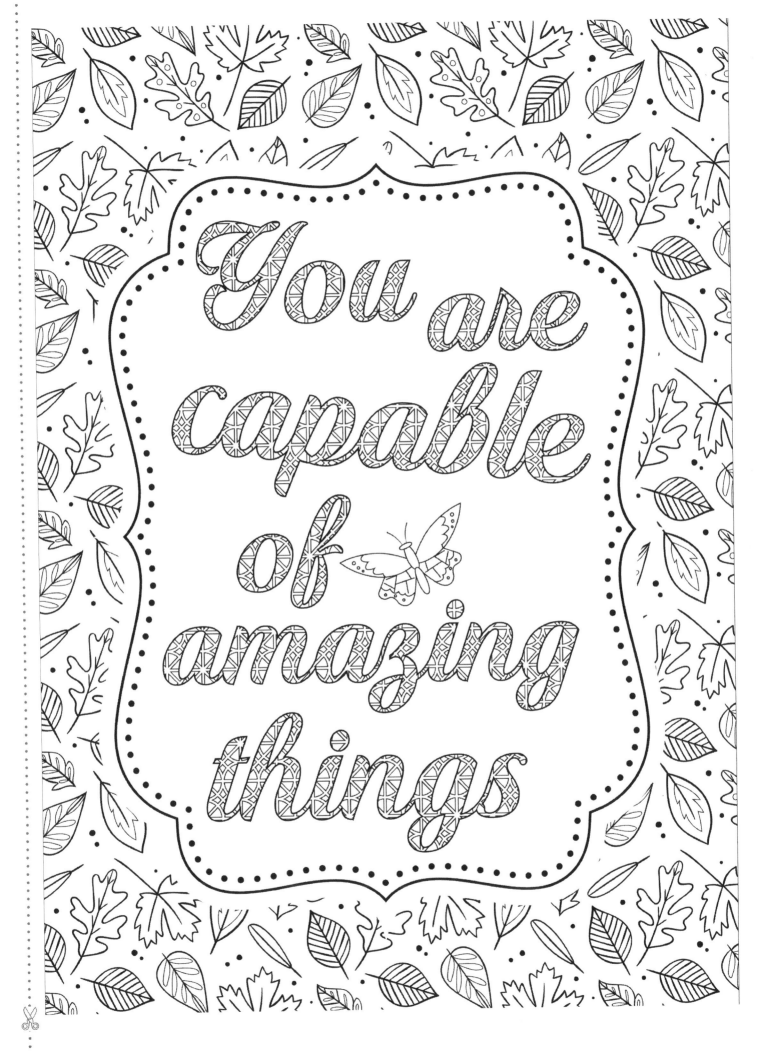

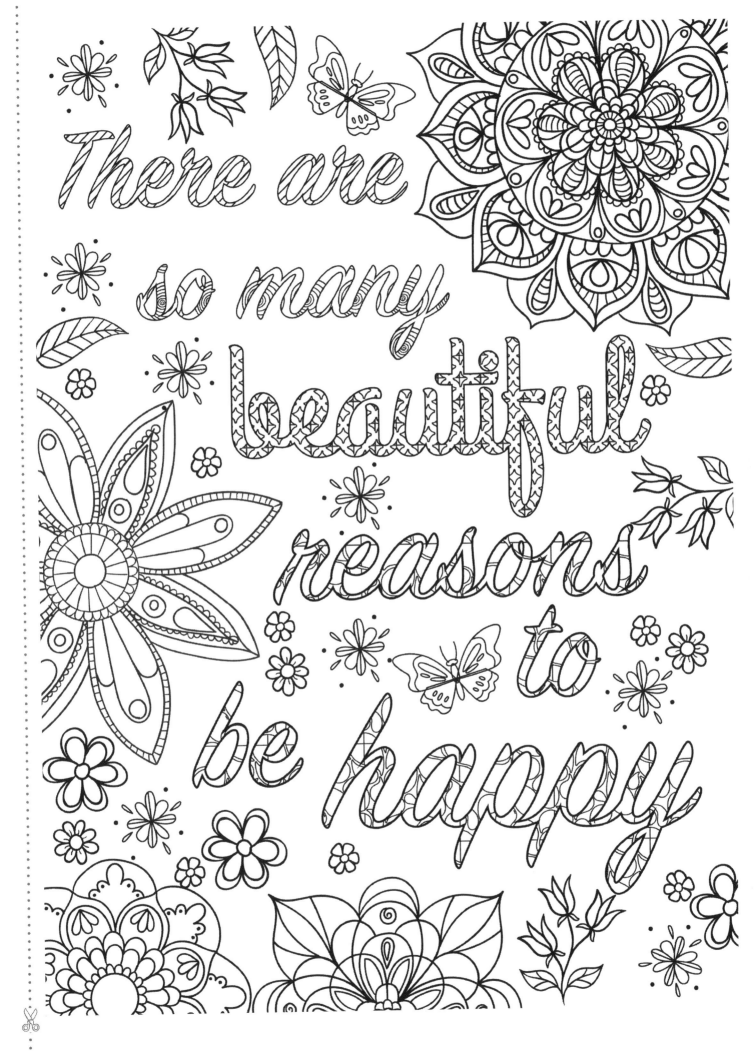

There are so many beautiful reasons to be happy

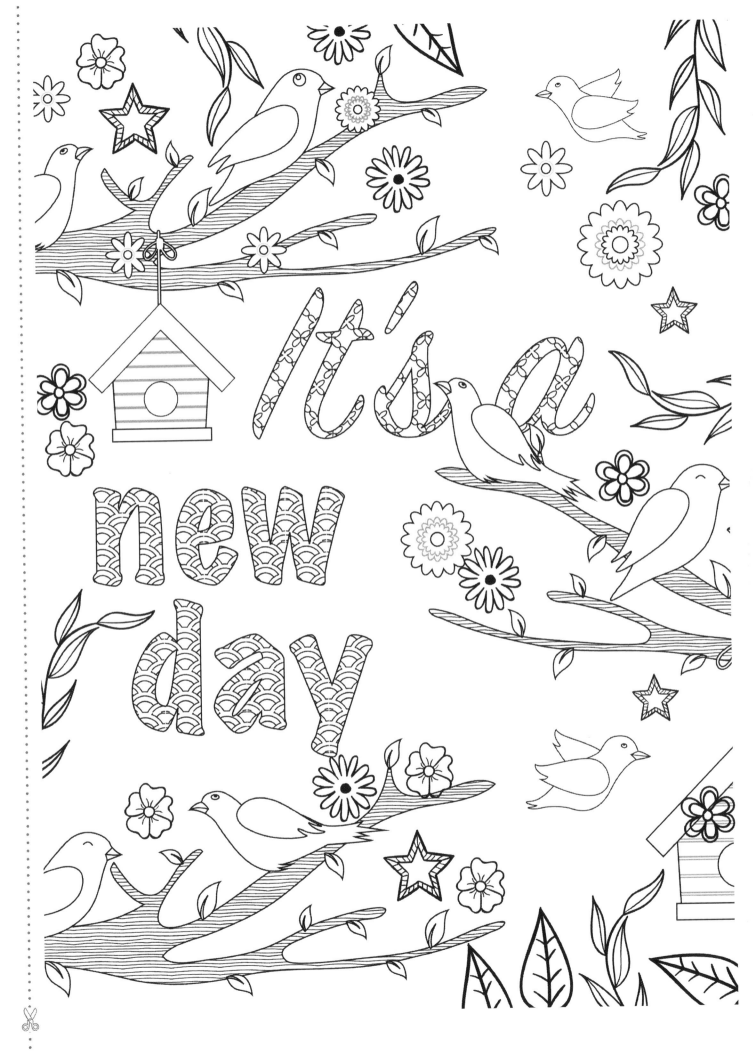

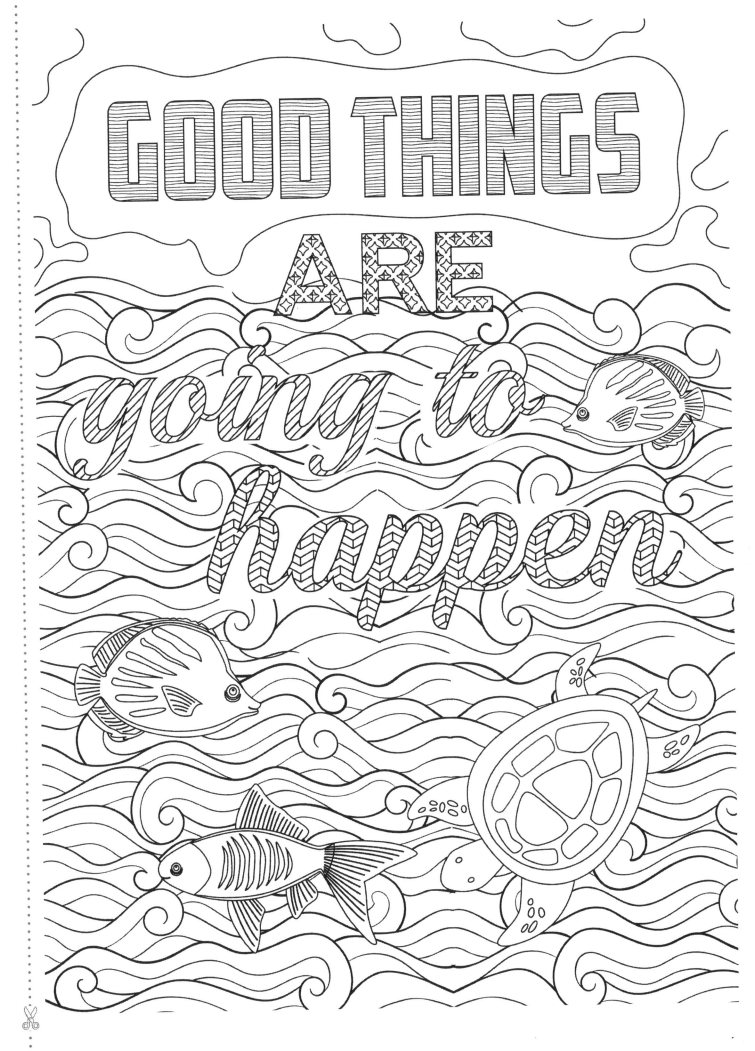

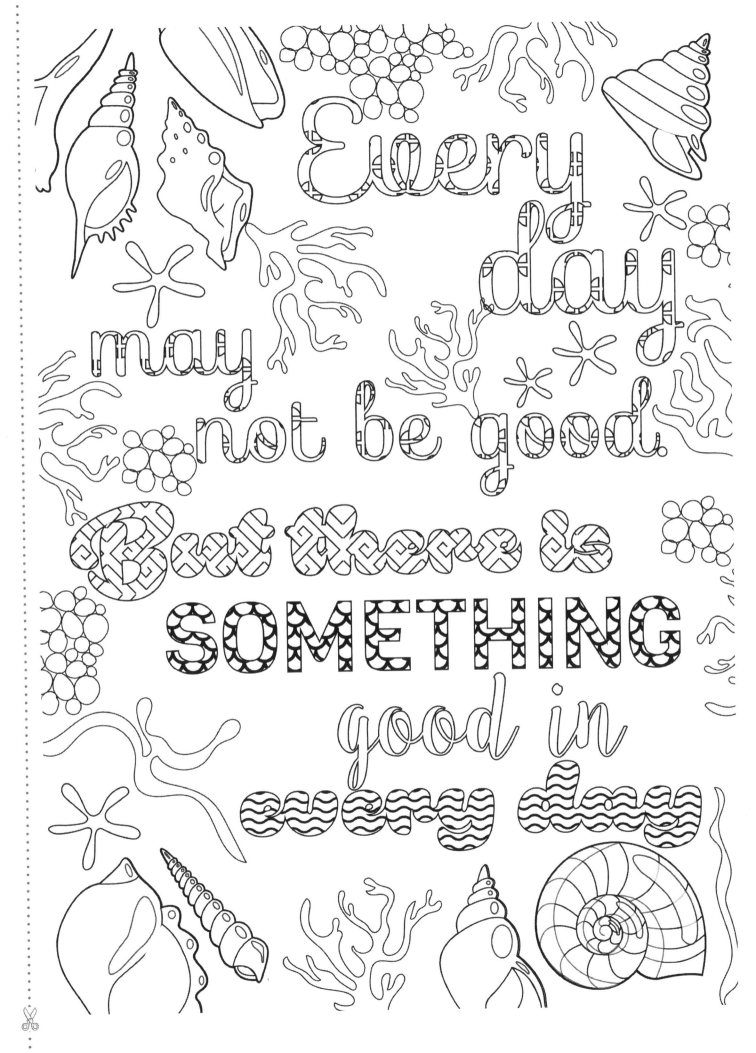

Every day may not be good. But there is SOMETHING good in every day

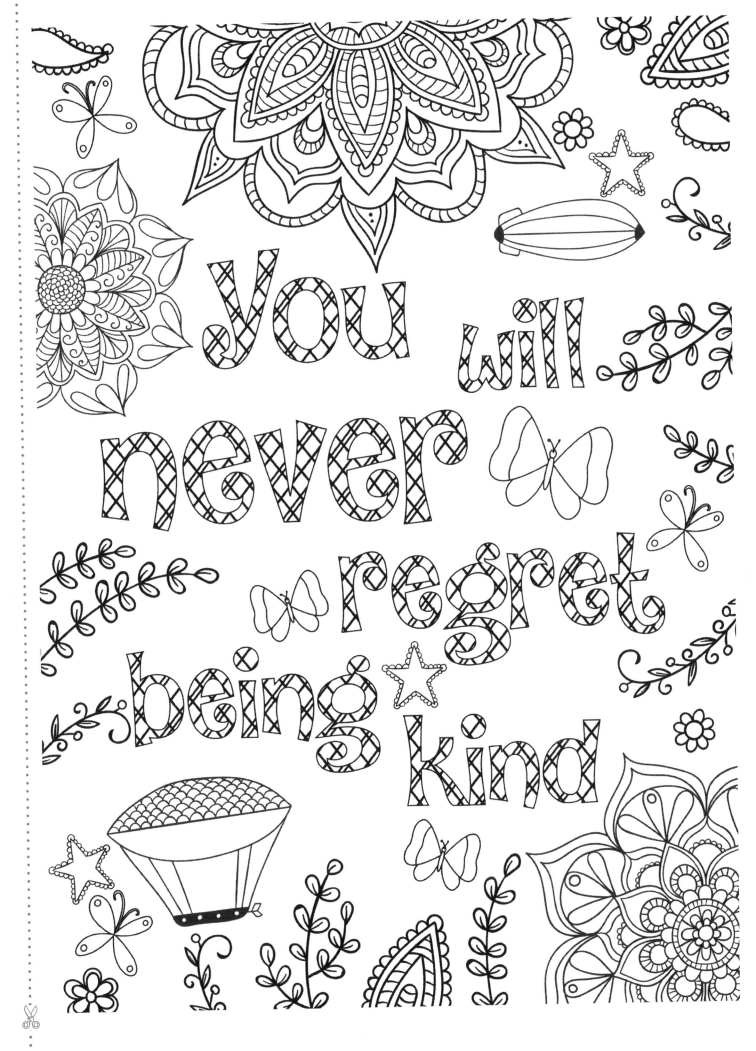

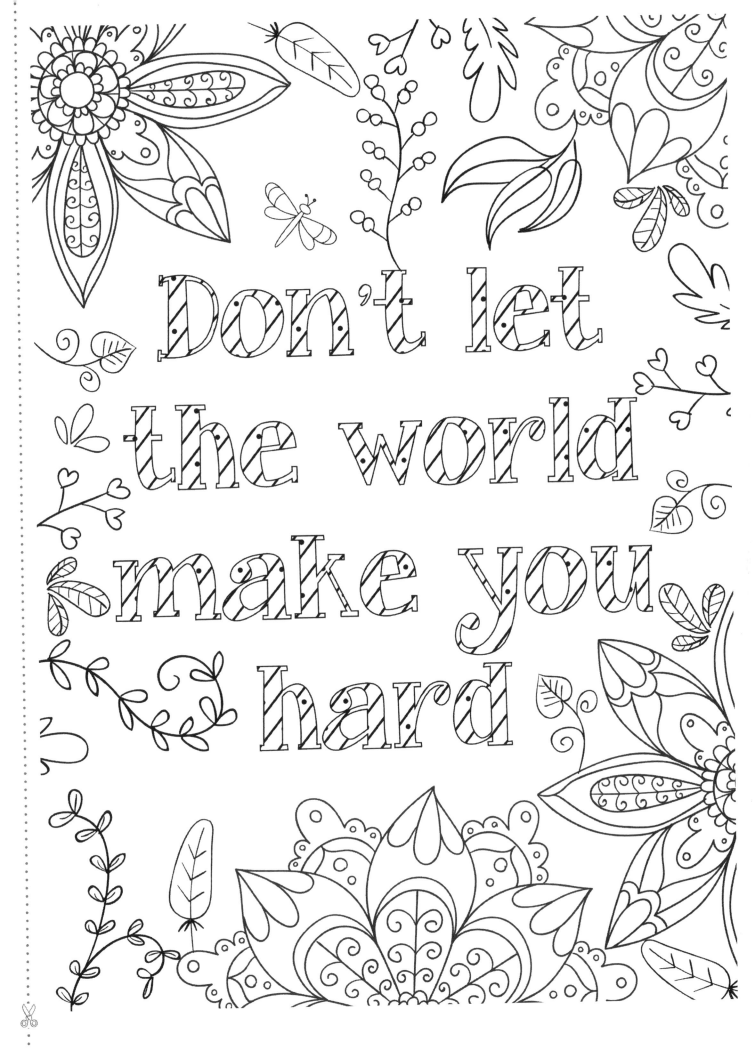

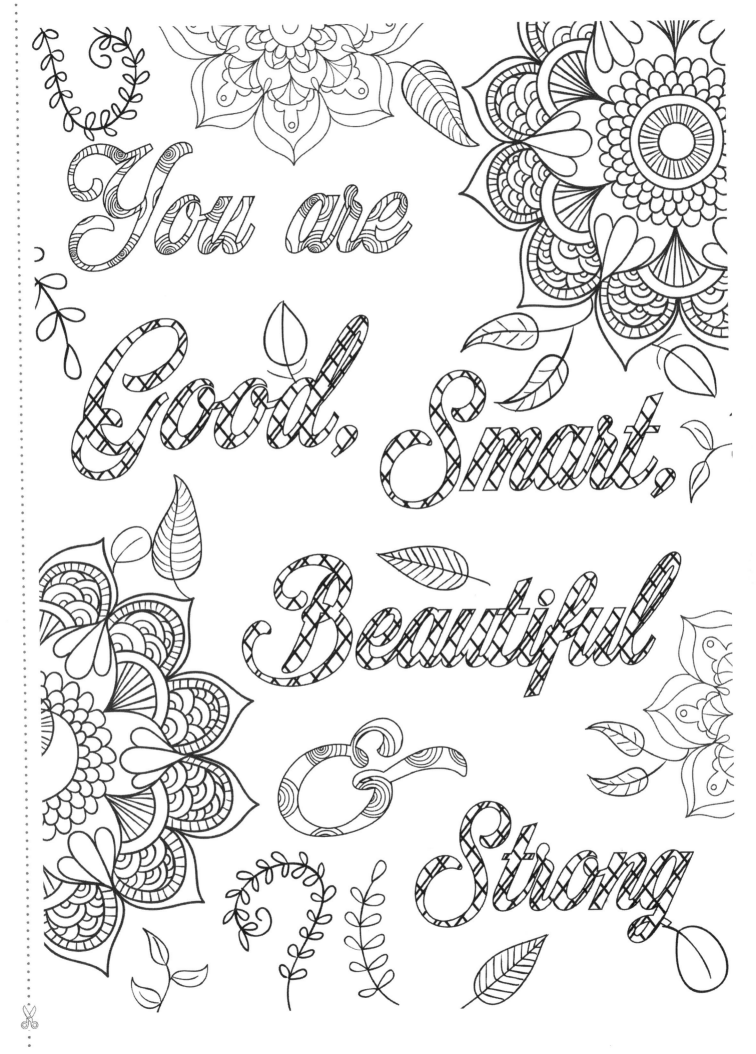

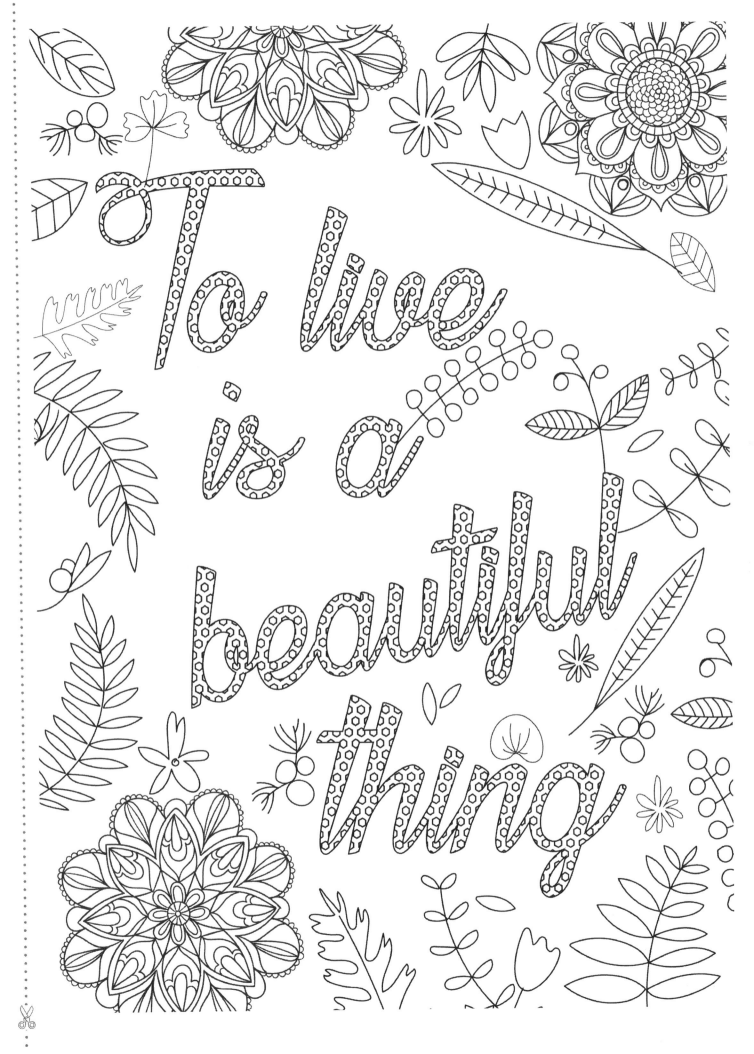

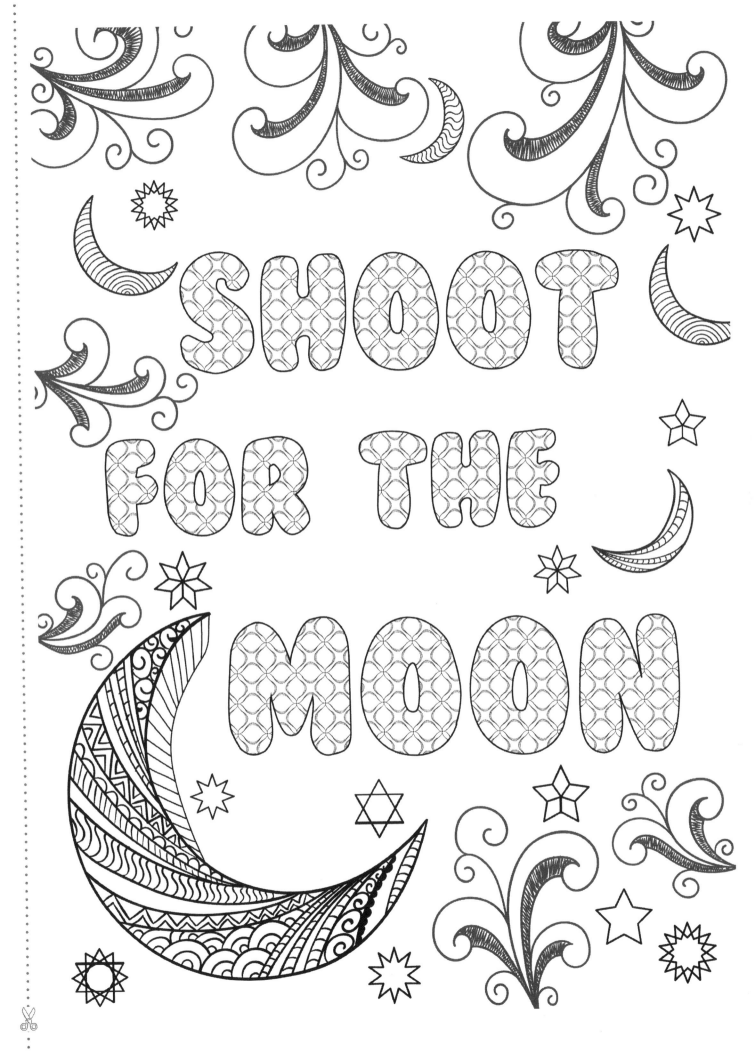

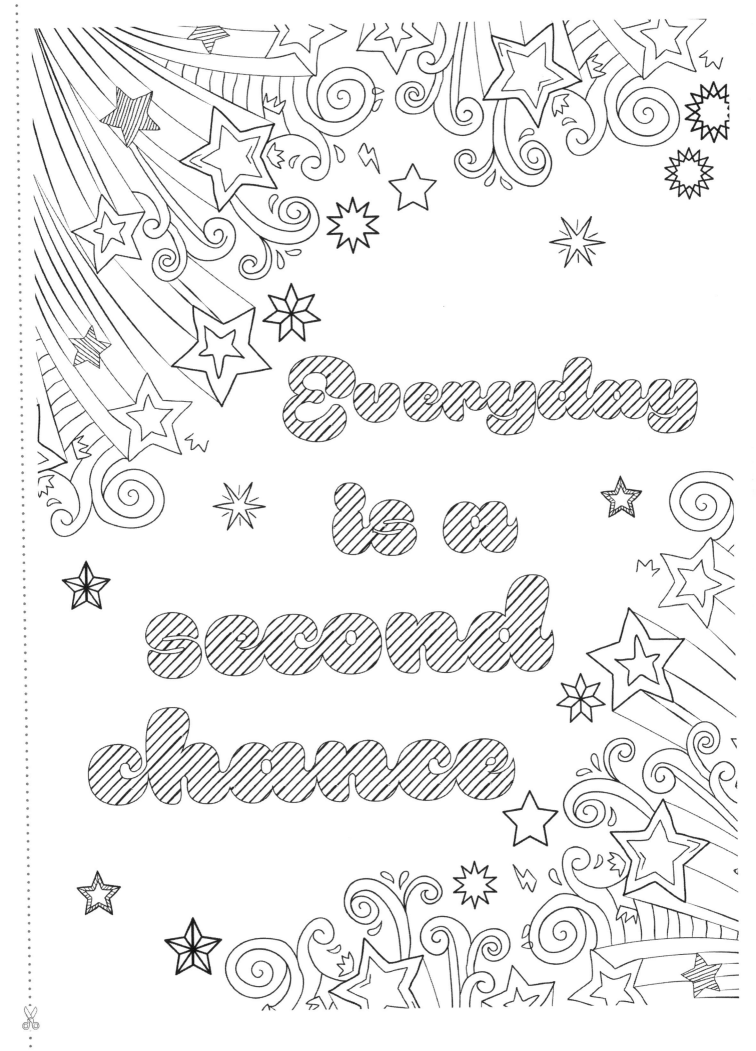

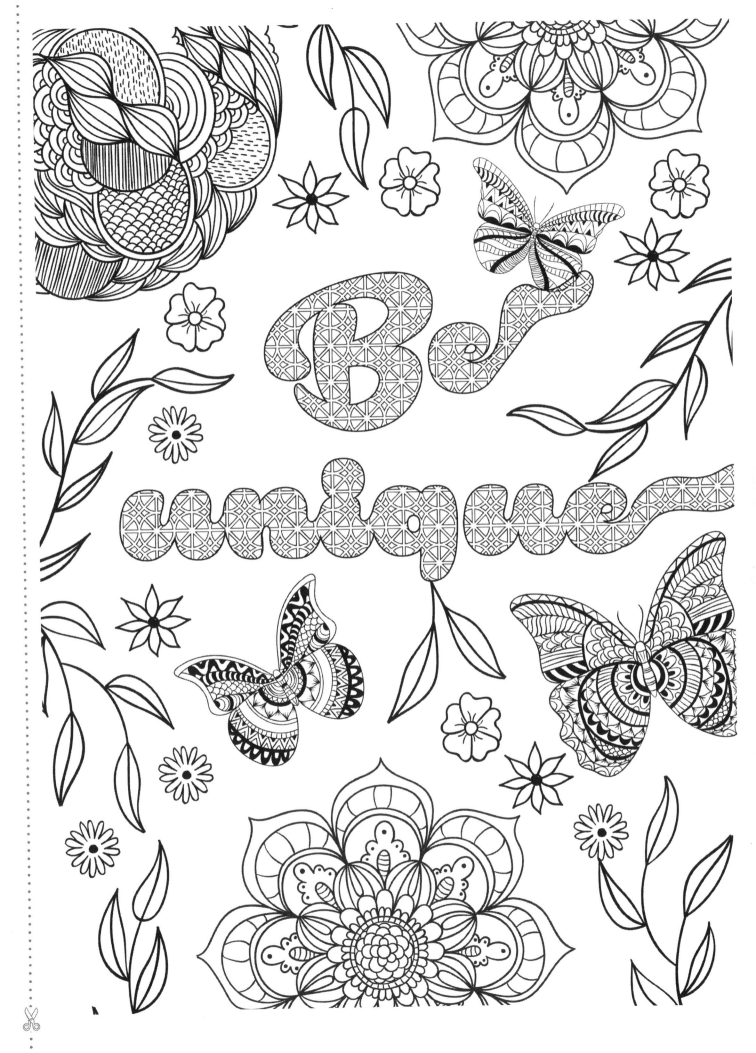

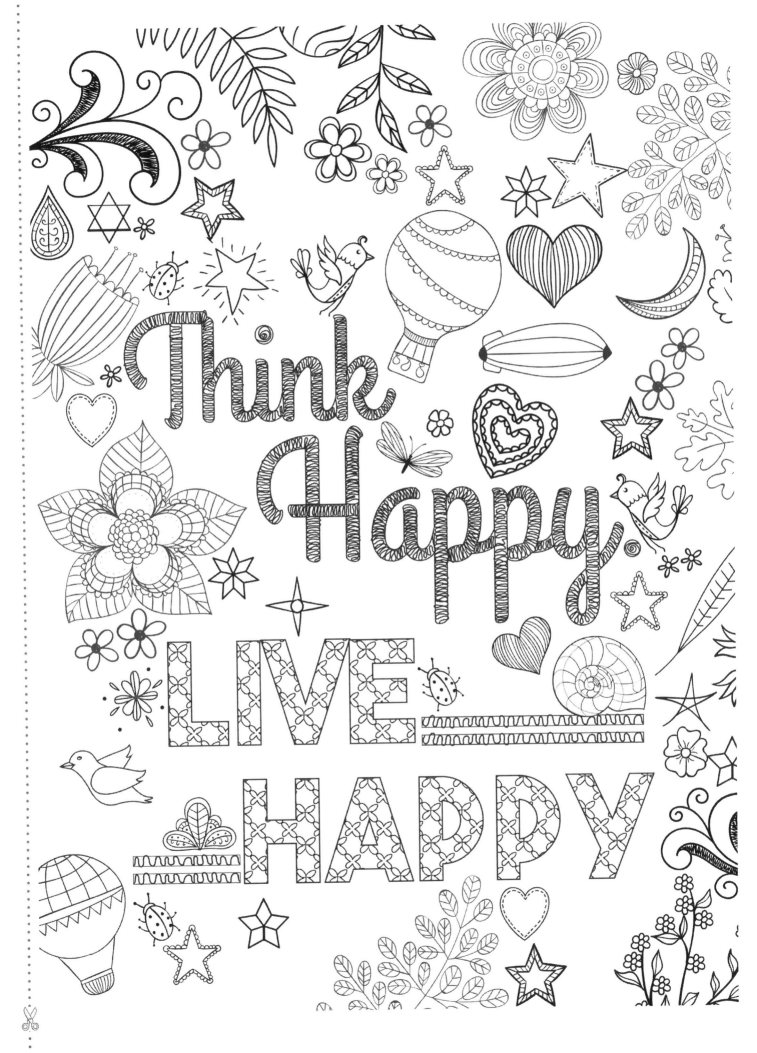

57074867R00038

Made in the USA
San Bernardino, CA
16 November 2017